CREATE COMICS

A SKETCHBOOK

chartwell
books

Brimming with creative inspiration, how-to projects, and useful information to enrich your everyday life, Quarto Knows is a favorite destination for those pursuing their interests and passions. Visit our site and dig deeper with our books into your area of interest: Quarto Creates, Quarto Cooks, Quarto Homes, Quarto Lives, Quarto Drives, Quarto Explores, Quarto Gifts, or Quarto Kids.

Artwork on pages 6-11 and 20-21 © 2014 Tim van de Vall; Artwork on pages 12-17 © 2014 Maury Aaseng; Artwork on pages 18-19 and 48-51 © 2014 Jim Campbell; Artwork on pages 22-23 and 42-45 © Joe Oesterle; Artwork on pages 24-39, 52-53, 56, 58-60 © Dana Muise; Artwork on pages 46-47 © Alex Hallatt; Artwork on pages 54-55 © 2013 Bob Berry.

This edition published in 2020 by Chartwell Books, an imprint of The Quarto Group,
142 West 36th Street, 4th Floor, New York, NY 10018, USA
T (212) 779-4972 F (212) 779-6058 www.QuartoKnows.com

Contains content previously published in 2017 and 2018 as *Create Your Own Comic Book Kit*, and in 2020 as *The Art of Comic Book Drawing* by Walter Foster Publishing, an imprint of The Quarto Group.26391 Crown Valley Parkway, Suite 220, Mission Viejo, CA 92691, USA.

Chartwell titles are also available at discount for retail, wholesale, promotional, and bulk purchase. For details, contact the Special Sales Manager by email at specialsales@quarto.com or by mail at The Quarto Group, Attn: Special Sales Manager, 100 Cummings Center Suite 265D, Beverly, MA 01915 USA.

10 9 8 7 6 5 4 3

ISBN: 978-1-63106-768-6

Publisher: Rage Kindelsperger
Creative Director: Laura Drew
Managing Editor: Cara Donaldson

Printed in China TT042021

TABLE OF CONTENTS

INTRODUCTION

"Comics" are a hybrid genre in which illustrations and written words work together to tell a story. While a children's storybook technically has a similar definition, comics are a very special and unique art form. Each page is filled with action, with "frame-by-frame" drawings each playing their part to keep the narrative going as you follow along. While it is a relatively new art form, today it exists with enormous representation and variety and serves as the occupation of tons of creative individuals. It even inspires other art forms, such as TV, film, and animation. With the advancement of technology, comics have also transcended beyond their origins in black-and-white newspaper prints to full-color graphic novels and digital formats, such as webcomics.

As the art of comics has gained popularity over the years, different countries have developed their own styles and titles, many of which have become internationally recognized. Heroes such as "Batman" and "The X-Men" are international hits, drawn by artists from all over the world. In Japan, mangaka, such as Osamu Tezuka, take the comic art form in its own amazing direction. France, the United Kingdom, and Korea also make up a small handful of many countries that have made monumental contributions to this art genre.

As you delve into this creative world with the help of this book, it is our hope that you will glean a deeper understanding and respect for the art form and eventually even create your own work. The lessons and projects in this book will help you build a strong foundation from the ground up: learning how to create a story; finding inspiration; and, most importantly, creating the characters that will make your story come to life for you and your audience.

Learning how to draw and create your own comic, will take patience, practice, and time. Remember that everyone starts at the beginning—even the best of us—so don't lose motivation!

Getting Started

This comic book interactive journal is broken up into simple sections where you'll find a series of exercises, prompts, and practice pages to fine-tune your skills. After learning how to create expressive cartoon characters with basic shapes and forms, you'll learn tons of tips and tricks to make your own comic book, from adding speech bubbles, captions, and sound effects to inking and creating your own story. And best of all, there are blank comic book pages at the end of the book to get you started.

Tools and Materials

You don't need many materials to create your own comics. Start with a simple pencil and eraser to sketch out your designs. Take your comics to the next level by inking them with markers. You can also color in your designs with markers, colored pencils, or even paint.

Pencils

Pencil lead, or graphite, varies in darkness and hardness. Pencils with a number and an H have harder graphite, which marks paper more lightly. Pencils with a number and B have softer graphite, which makes darker marks. A good pencil for sketching is an H or HB, but you can also use a regular No. 2 pencil.

Erasers

Vinyl and kneaded erasers are both good to have on hand. A vinyl eraser is white and rubbery and is gentler on paper than a pink eraser. A kneaded eraser is like putty. It can be molded into shapes to erase small areas. You can also use it to lift graphite off paper to lighten artwork.

Markers

Professional art markers create bold, vibrant bands of color. They are great for laying down large areas of color, as well as for shading. Fine-line markers produce lines that are very easy to control, making them perfect for inking and coloring your comics.

Creating Characters

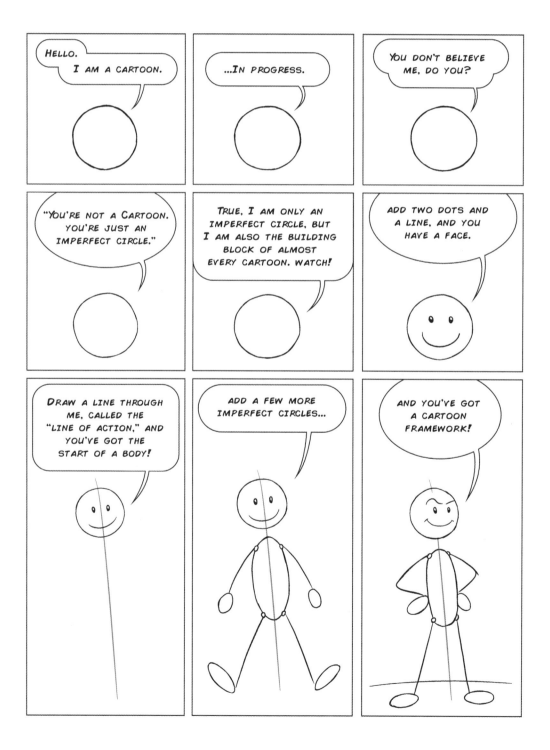

FRAMEWORK

The first step in creating cartoon characters for your stories is to create a framework for their bodies. It's pretty simple really—just a circle for a head and some lines and ovals, and you're good to go!

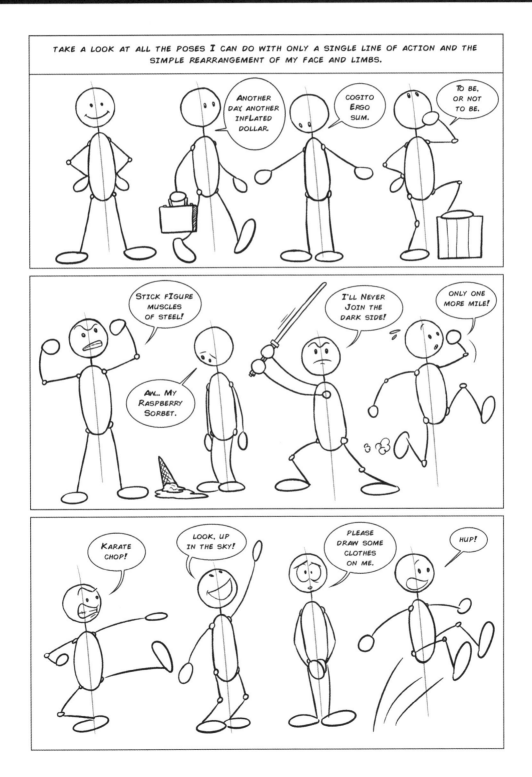

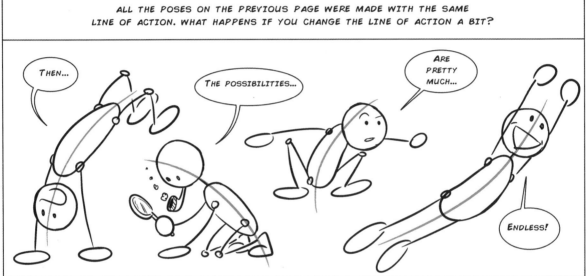

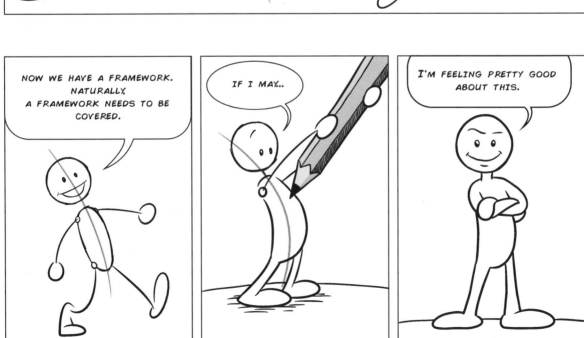

STILL, WE'VE GOT A LONG WAY TO GO BEFORE I'M COMPLETE. FOR INSTANCE, I WOULDN'T MIND HAVING ACTUAL HANDS. LET'S DRAW SOME!

START BY DRAWING A CIRCLE. (BET YOU DIDN'T SEE THAT COMING.)

NOW ADD SOME FINGERS. THREE SHOULD BE ENOUGH.

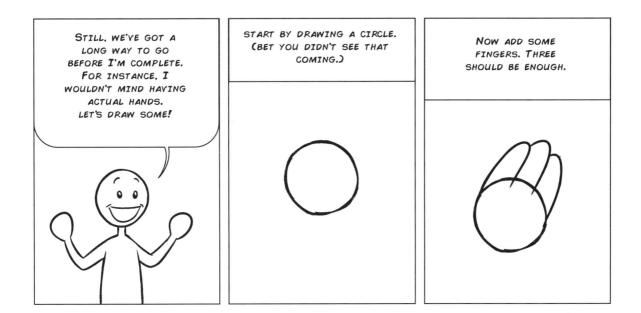

FINALLY POP ON A THUMB, THROW IN A FEW MORE LINES, AND VOILÀ! CARTOON HANDS!

AH, IT'S GOOD TO HAVE OPPOSABLE THUMBS.

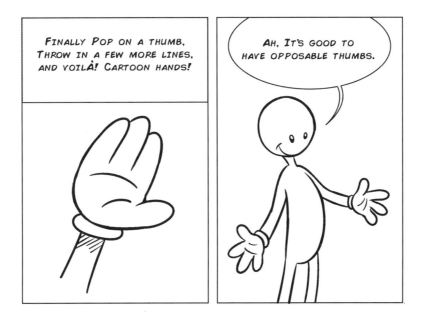

IT'S YOUR TURN!

Try drawing your own cartoon bodies and heads using these lines of action, and create some of your own too!

HEADS & BODIES

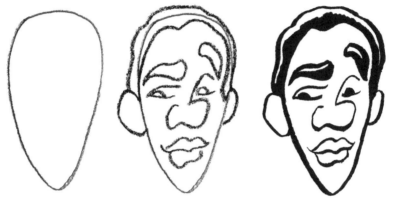

A carrot shape sets the stage for a strong-jawed, confident man, suggesting that a tall, lean body accompanies the character's face.

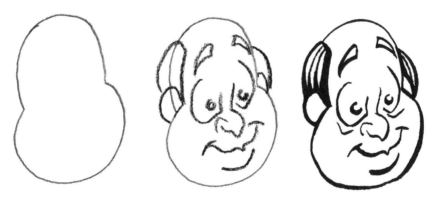

A pear shape and some jolly features give this fellow the look of a happy butler.

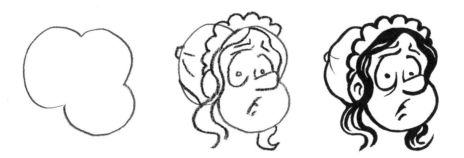

With this strange popcorn-like shape, one bump becomes the cheek, another bump becomes the forehead, and the third bump becomes the bonnet of this housemaid.

Much of a character's personality and attitude can be captured with the initial simple shape. For instance, a shape with sharp angles can suggest an angry or intense person; wide, round shapes can suggest a comfortably idle character; and a strange shape often suggests an awkward character. Try as many different shapes as you can—you may be surprised at the variety of characters that live in your head!

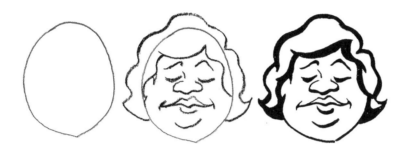

A proud woman can emerge out of a wide oval with a pointed bottom tip. Her closed eyes and lips and a maintained hairstyle reflect a woman with a no-nonsense attitude!

An elongated trapezoid provides the shape of an exhausted and yawning man. An asymmetrical shape for his mouth and vertically stretched eyes suggest the bizarre look of a face when captured mid-yawn!

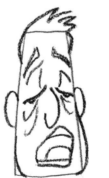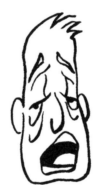

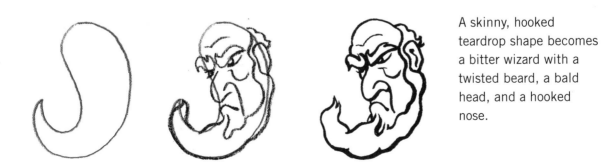

A skinny, hooked teardrop shape becomes a bitter wizard with a twisted beard, a bald head, and a hooked nose.

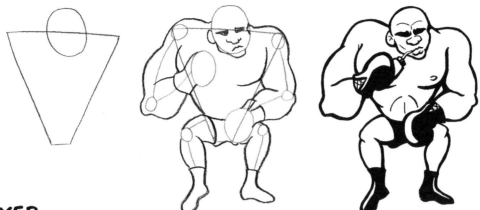

BOXER

A circle and an inverted trapezoid create the powerful body of an intimidating boxer. To create his limbs, draw lines with circles marking the joints before adding the beefy flesh surrounding them. Add some tough-guy features, such as a lumpy nose and eyebrows so dark and thick they hide his eyes.

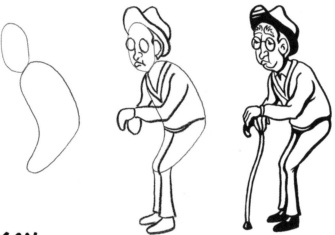

ELDERLY MAN

A boomerang shape creates the sloping back of this hunched man. Use a simple, elongated oval for the head and then sketch in his limbs, hat, and facial features. After adding bushy eyebrows, thick glasses, and a rubber-tipped cane, this guy's ready to hit the bingo hall!

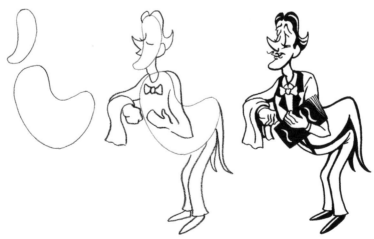

WAITER

Start with two abstract, curved shapes floating near each other (one marking the head, the other the body). After connecting the shapes with a noodlelike neck, accompanied by noodlelike legs and arms, the waiter character begins to take shape. His appearance is heightened by his exaggerated posture, silly tuxedo, and the swoop of hair and tiny mustache.

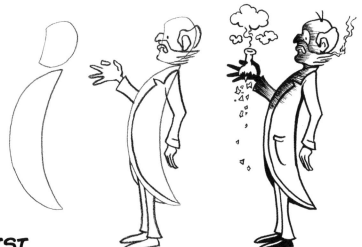

SCIENTIST

A banana shape for the body is perfect for this absent-minded scientist. The inward-sloping back suggests movement and surprise. Draw an oval with one flat side for the head and add arms, legs, hands, and facial features, including a beard. All that's left to add is the broken vial, some smoke, and dark hatch lines to illustrate how this genius "got burned" by an experiment gone wrong.

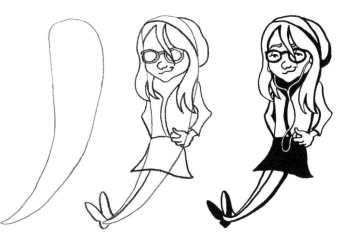

HIPSTER

A chili pepper shape captures the posture of this young hipster. Add an arm off to one side, and the tip of the chili becomes indistinct legs leaning on a wall. The top morphs into a girl's head wearing a floppy hat, dark-framed glasses, earbuds, and a smug expression. If only her parents understood her.

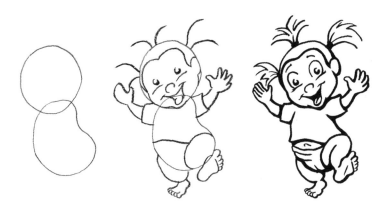

TODDLER

A lima bean with a large circle on top creates the framework for a rambunctious toddler. Stubby legs, outstretched hands, and the face at a tilted angle creates the look of a tiny kid dashing toward something (or someone) exciting. Three fountainlike ponytails, an exposed belly button, and a visible tongue help create the young toddler's expression of uninhibited enthusiasm.

IT'S YOUR TURN!

Practice turning the shapes and forms below into personalized heads and bodies.

FEATURES

Now you've got to give your characters some personality. What shape is their face? What kind of nose do they have? Each feature you give a character should reflect their personality, so choose wisely!

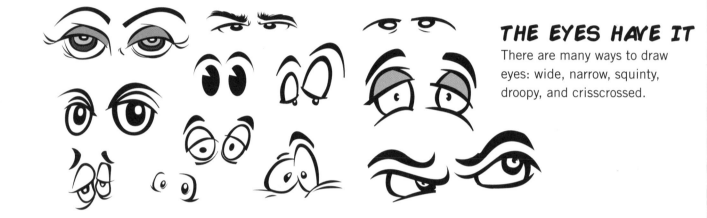

THE EYES HAVE IT

There are many ways to draw eyes: wide, narrow, squinty, droopy, and crisscrossed.

THE NOSE KNOWS

On its own, the nose doesn't necessarily convey emotions, but it does crinkle when it smells something bad, elongates slightly when in shock or surprise, and flares the nostrils in anger or determination.

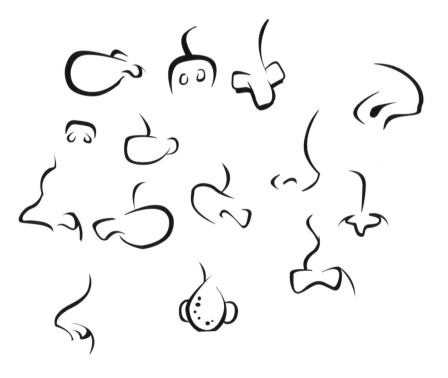

Want to know the best thing about being a cartoonist? You're never wrong! Mathematicians can be wrong, scientists can be wrong, and we all know that the people who cut your hair can be wrong. Because you're creating a character the way you see it in your head, it's never wrong.

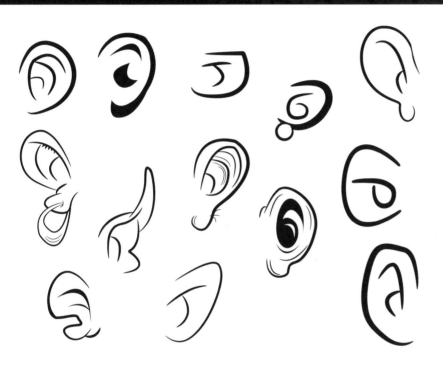

I HEAR YOU

Ears can be C-shaped or V-shaped. Some might wear earrings. And how can people hold up their glasses if not for specially designed ears?

MOUTHING OFF

Perhaps the most important facial feature when trying to convey emotion is the mouth. The mouth has more working parts than the eyes or nose, giving the cartoonist more elements to play with and exaggerate.

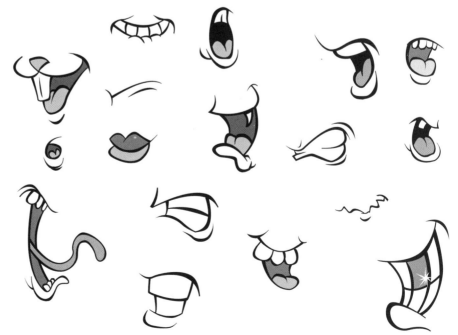

Fill in the features of these comic characters and try out different noses, eyes, mouths, and hair. Want an extra challenge? Name each character too!

OK, show of hands. Everybody who hates drawing hands raise your right hand. Now everybody who really, really hates drawing hands raise your left hand. Allow me to share a little cartooning secret with you: Nobody likes drawing hands. Drawing hands is like eating broccoli or multiplying fractions. You don't want to do it, but it's good for you. There are numerous books and tutorials on the Internet to teach you the rules of drawing realistic hands. But who cares? We're cartoonists. We don't need no stinkin' rules.

Sure, if you want, you can draw realistic-looking hands...

...or you can make your hands look like wet noodles...

...or bendable sausages.

In cartooning, hands can have five fingers...

...or four,

HANDS CAN BE A COMPELLING AND PERSUASIVE WAY TO CONVEY EMOTION AND EXPRESSION.

but there's no reason a character can't have as many or as few fingers as you'd like.

Feet can be even more fun to draw than hands because no one expects any emotion or personality from them.

The just-off-work foot

The "kick back" cowboy

A ballerina-or aspiring ninja

A pirate or caveman

Sometimes four toes are better than five

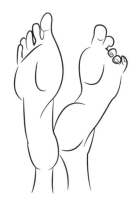

Nothing scratches the bottom of your own foot like your other foot

These feet are about to dip themselves in the ol' waterin' hole

Holes in socks can say, "I need a job" or "I'm too lazy to buy new ones."

And of course, the stink foot

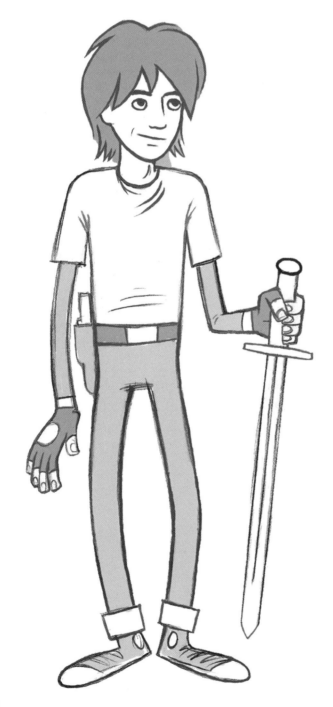

Use a light (hard) pencil for the rough layout: HB or H

Now that you've learned to draw all the body basics, it's time to start drawing bodies in motion. Most books say you need to study anatomy to draw people. The characters we will draw are more cartoonish, so don't worry if things aren't perfect. As long as you have fun drawing, that's what really matters!

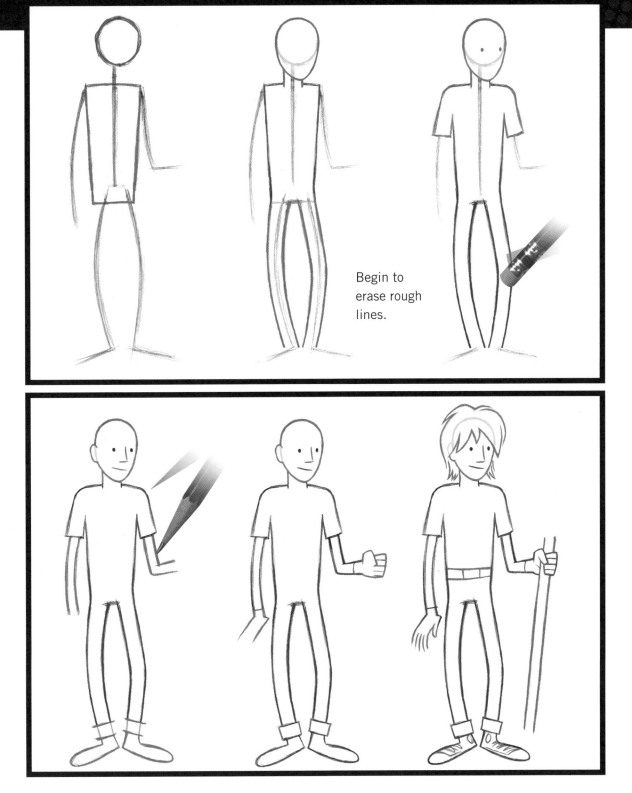

Begin to erase rough lines.

See, that wasn't so hard! Let's try another one, this time an action pose.

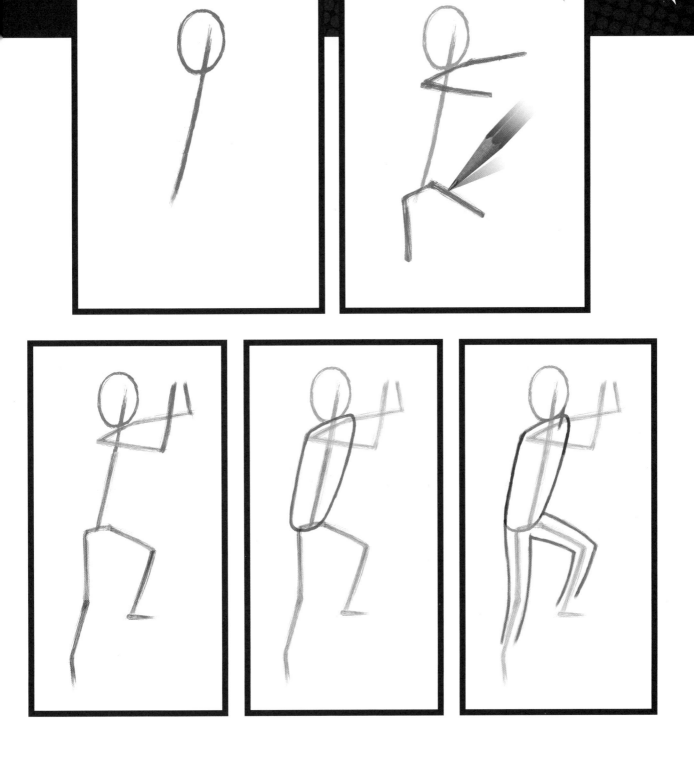

27

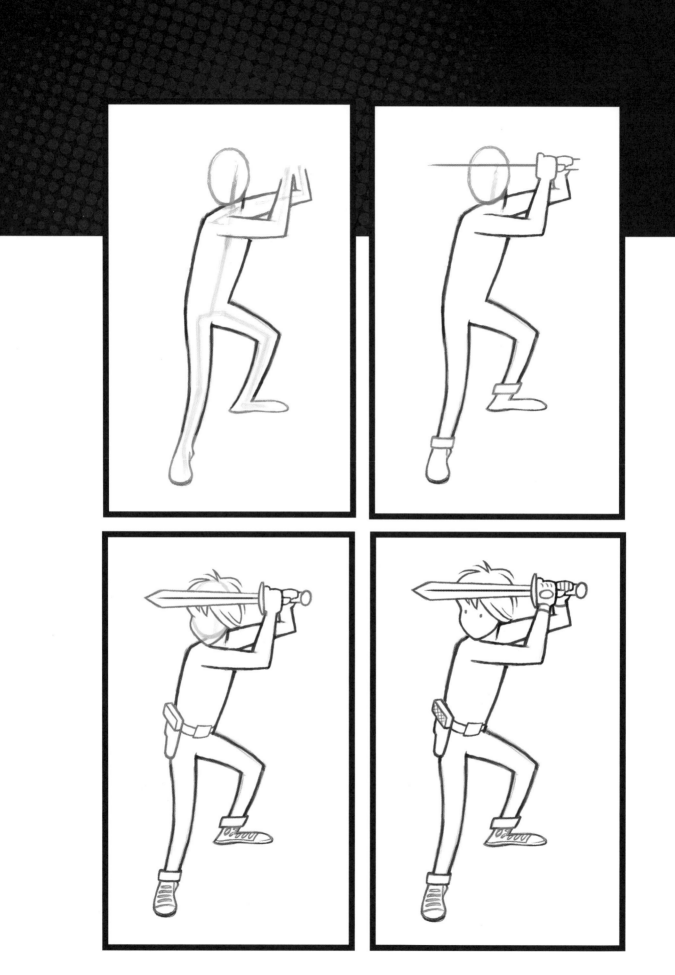

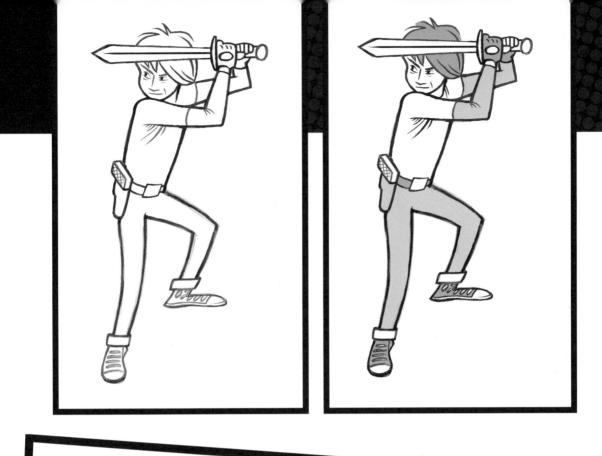

A good way to show movement in comics is with action lines. They can show where an object came from and where it's going.

Villains

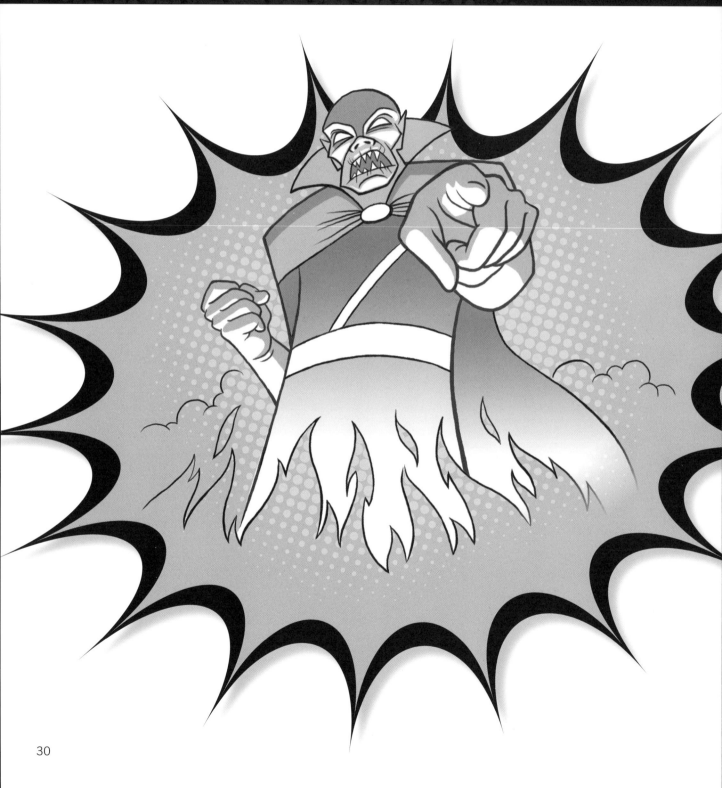

Every hero needs a nemesis to help him shine. Monster of the Deep? Raptor of the Skies? Whether human or animal, alien or beast, the origins of your villain will help you determine his shape and features.

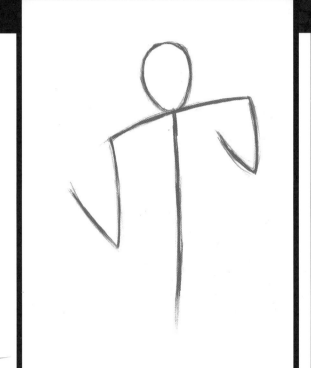

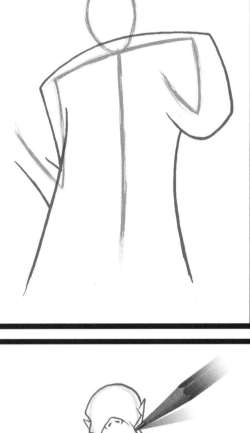

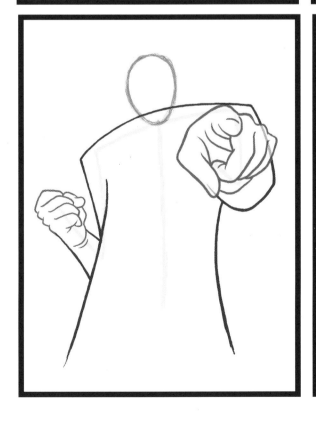

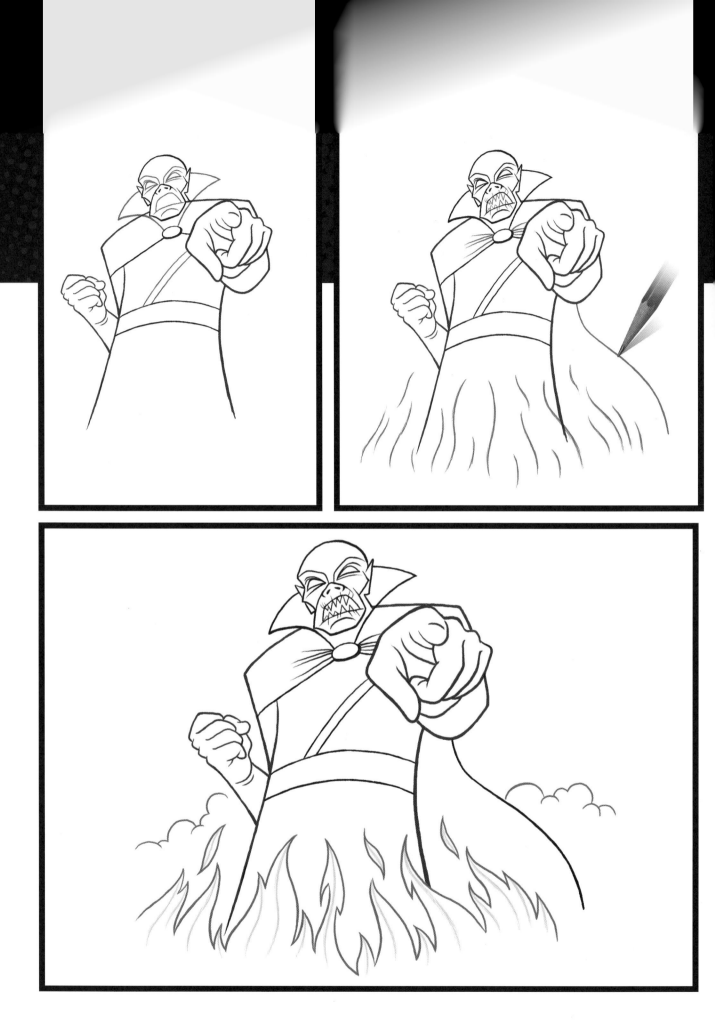

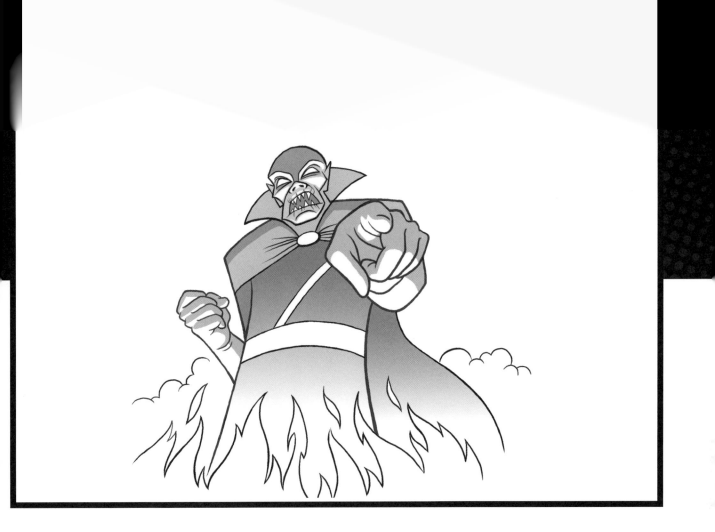

NOTES ABOUT FORESHORTENING

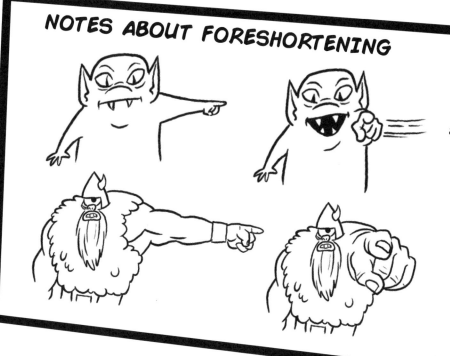

Foreshortening happens when something long is pointing straight at you and the length is hidden. If you're drawing a little guy with short arms, keep the hand small.

But with a big guy with long arms, make the hand much bigger. It increases the foreshortening effect.

33

HEADS

The most important part about creating a head is the face. It says everything about the personality. The eyes, nose, ears, and mouth can be anyplace or nowhere at all. Below are a few examples of very different alien creatures created with the same basic shapes.

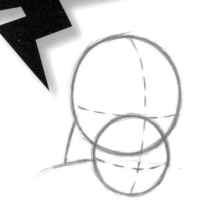

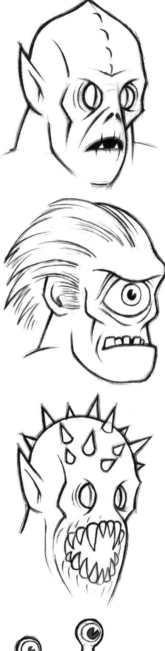

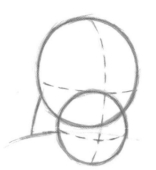

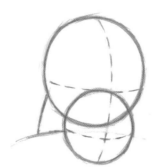

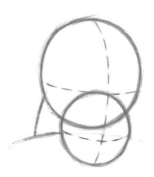

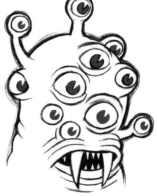

EYES

If you're going to draw eyes at all, the placement and size is important. Big bug eyes are good for brainy time travelers, whereas deep-set, hooded eyes depict more strength and dominance. Many alien eyes are drawn without pupils. This makes the creature look more mysterious. Drawing the two eyes different sizes creates a more deformed or mutated alien.

Deep-set, hooded eyes create a sinister, mysterious look.

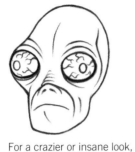

For a crazier or insane look, try pushing the eyes outward, popping out of the head.

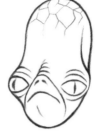

Lowering the eyes to nose level makes your creature more amphibious, or frog-like.

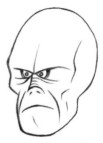

Placing very small eyes close together make for a dumb or easily frustrated character.

NOSES

Most artists ignore the nose when designing aliens, or they make it very small. Be different—add a prominent snout on your beast.

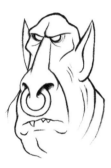

Big creatures are more likely to have a big nose. Add some nose jewelry to give him the look of an ancient race.

Insect aliens can have noses too. It's a good place to have a deadly stinger.

Don't be afraid to use animal noses on your aliens. This guy has the snout of a wild boar.

The head of a dino-reptilian character is almost all nose.

TEETH

Nothing makes a character more threatening than a mouthful of razor-sharp teeth. Fangs and such can be a little tricky at first. It's helpful to examine the skull of an actual predator, such as an alligator or tiger.

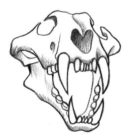

When drawing fangs, it helps to study the skull of an actual predator.

Crooked and chipped teeth with an under bite can look menacing.

Popular Hollywood aliens sometimes have a mouth within a mouth.

Battles

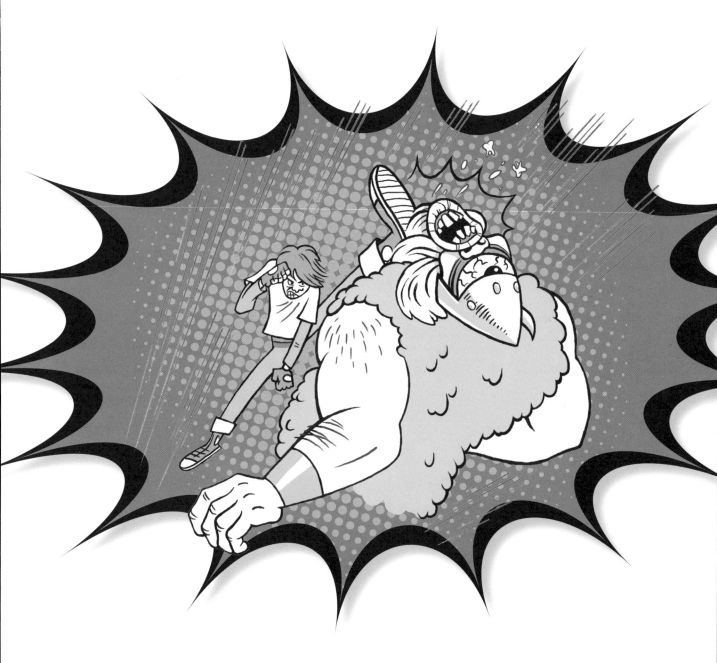

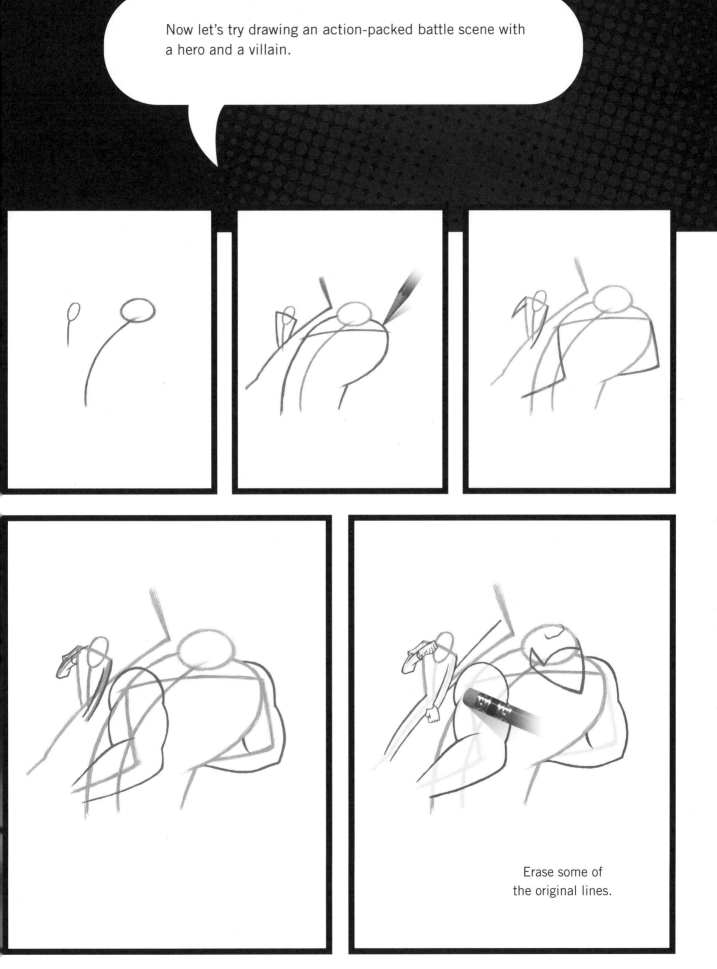

Now let's try drawing an action-packed battle scene with a hero and a villain.

Erase some of the original lines.

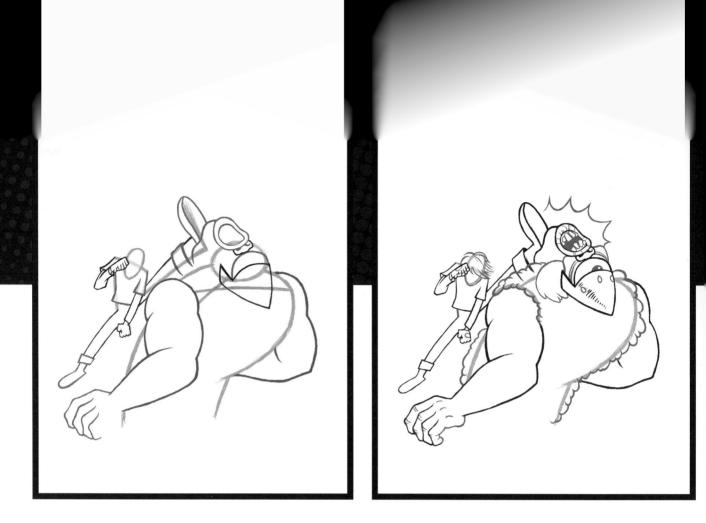

The speed lines on the next page all start from the same point, although it is far off the page. To make your own speed lines, mark a center point on your drawing board with a light pencil. Use a ruler and pivot on that point, drawing groups of lines at different places.

Mark a spot on your drawing surface.

Pivot the ruler on that spot while drawing lines.

Speed lines should start bold and end fine. This is easy to achieve in pencil. Just reduce the pressure on the pencil as you draw.

Japanese illustrators use speed lines to add action to a scene. They're easier to make than you think! Try adding them to your artwork.

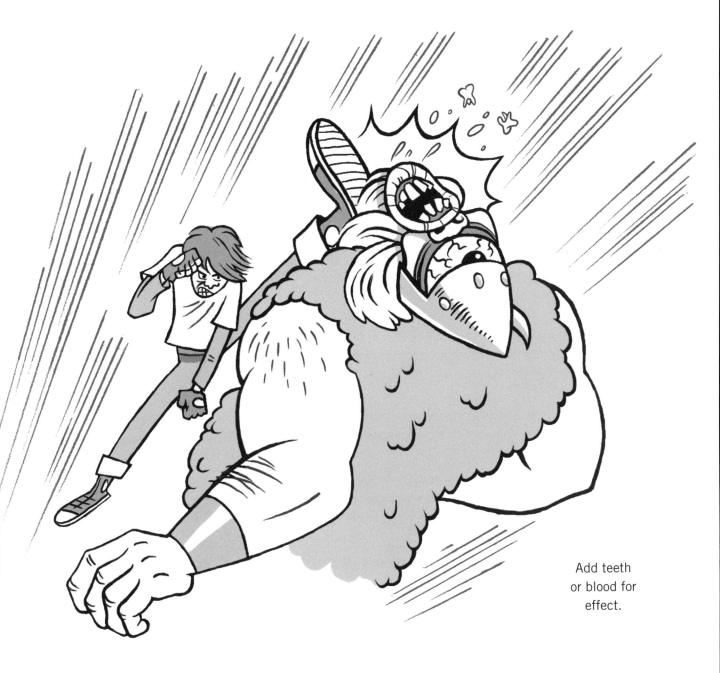

Add teeth or blood for effect.

IT'S YOUR TURN!

Brainstorm your own epic villain in the space below, and create a battle scene using foreshortening and speed line tricks.

Adding Speech

SPEECH BUBBLES & CAPTIONS

Speech or narration can be contained in different shaped balloons depending on the nature of the text. These balloon types are: speech, double outline, burst, radio, thought, whisper, and weak. Can you tell which of these balloons is an example of each of these types? (See answers at the bottom of the page.)

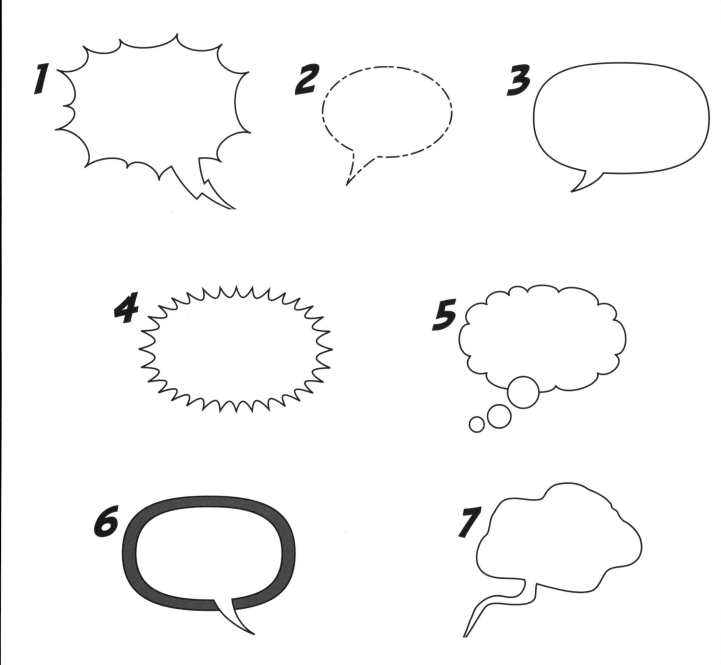

ANSWERS: 1 – BURST; 2 – WHISPER; 3 – SPEECH; 4 – RADIO; 5 – THOUGHT; 6 – DOUBLE OUTLINE; 7 – WEAK.

BURST BALLOONS

Burst balloons are used for shouting, screaming, alarm, or any kind of speech that may require extra emphasis. You can combine them with larger text, a bolder font, or both!

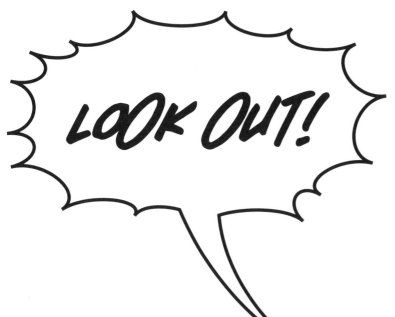

LOOK OUT!

TRY NOT TO USE TOO MANY POINTS; THE LOOK OF THE BURST BALLOON HAS RELATIVELY FEW POINTS TO DISTINGUISH IT FROM THE RADIO BALLOON.

BALLOONS

Also known as a thought bubble, the thought balloon is a useful method of giving the reader quick and immediate insight into what a character is thinking or feeling in a way that narrative caption may sometimes fail to do. Note that text inside thought balloons is usually italicized.

WHAT ON EARTH IS THAT?!

THOUGHT BALLOONS ARE ALMOST THE SAME AS BURST BALLOONS. DRAW A SET OF SMALL CIRCLES THAT GET SMALLER THE CLOSER THEY ARE TO THE CHARACTER.

WHISPER BALLOONS

Whisper balloons are somewhat out of fashion today. Many letterers prefer the use of a lowercase lettering font to show that a character is whispering, but the use of a traditional whisper balloon is still perfectly valid.

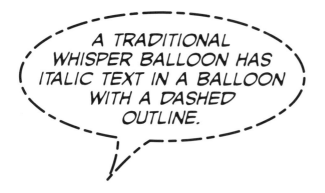

A TRADITIONAL WHISPER BALLOON HAS ITALIC TEXT IN A BALLOON WITH A DASHED OUTLINE.

Although a normal balloon with lowercase text is more often preferred in recent years.

WEAK BALLOONS

Weak balloons differ from whisper balloons in that they are used to show dialogue that is quiet as the result of the speaker being ill, injured, or incapacitated.

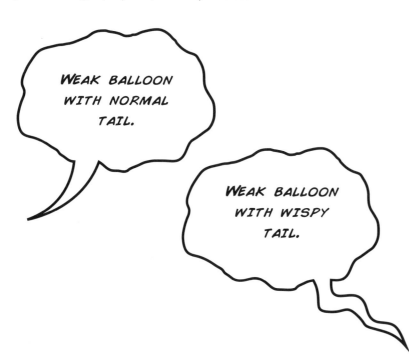

WEAK BALLOON WITH NORMAL TAIL.

WEAK BALLOON WITH WISPY TAIL.

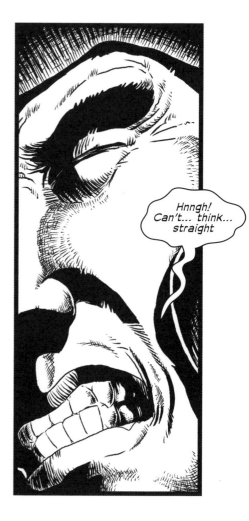

Hnngh! Can't... think... straight

LINKED BALLOONS

Linked balloons connect lines of dialogue from the same speaker that are not continuous. If a character has two consecutive lines of dialogue that are not directly related, the balloons should be linked rather than joined.

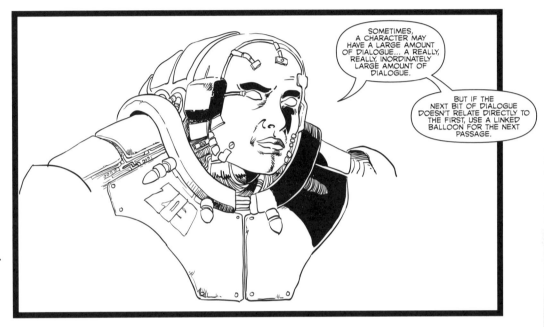

SOMETIMES, A CHARACTER MAY HAVE A LARGE AMOUNT OF DIALOGUE... A REALLY, REALLY, INORDINATELY LARGE AMOUNT OF DIALOGUE.

BUT IF THE NEXT BIT OF DIALOGUE DOESN'T RELATE DIRECTLY TO THE FIRST, USE A LINKED BALLOON FOR THE NEXT PASSAGE.

CAPTIONS

Captions are reserved for narrative text, either third person or first person. They can also be used for voice-over text—dialogue that is spoken aloud by a character not present in the current scene. In this case, the text also uses quotation marks.

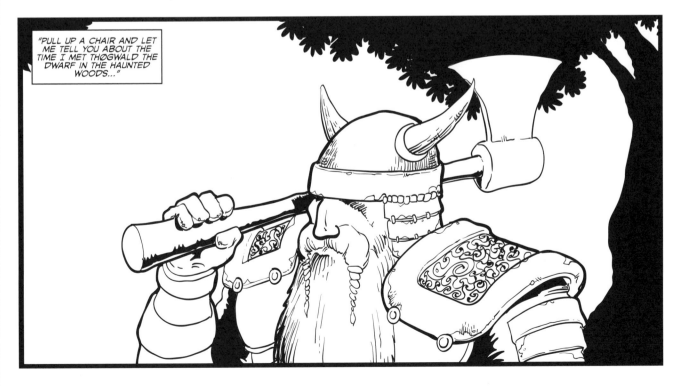

"PULL UP A CHAIR AND LET ME TELL YOU ABOUT THE TIME I MET THØGWALD THE DWARF IN THE HAUNTED WOODS..."

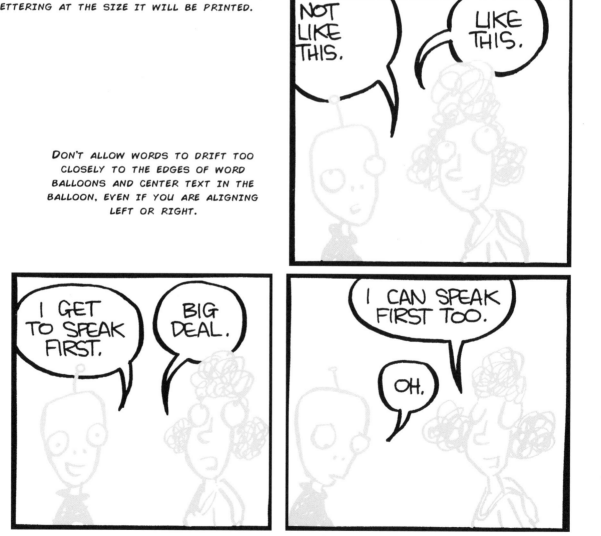

MAKE SURE OTHER PEOPLE CAN EASILY READ YOUR LETTERING AT THE SIZE IT WILL BE PRINTED.

DON'T ALLOW WORDS TO DRIFT TOO CLOSELY TO THE EDGES OF WORD BALLOONS AND CENTER TEXT IN THE BALLOON, EVEN IF YOU ARE ALIGNING LEFT OR RIGHT.

ENSURE THAT THE ORDER OF THE BALLOONS REFLECTS THE ORDER IN WHICH THE CHARACTERS ARE SPEAKING. PEOPLE WILL READ FROM LEFT TO RIGHT OR TOP TO BOTTOM.

Don't cross word balloon tails. Redraw the panel, or rearrange the word balloons.

Avoid loose tails: they should point to the character who is speaking—ideally to their head.

If you overlap your drawing into a word balloon, don't let the line cut into their eye level.

ARTIST'S TIP

The way you letter and draw borders and balloons is a huge part of the your strip's "look." It doesn't matter if you break a few rules, as long as the strip is legible.

Practice adding text to the speech bubbles below. Remember, the shape of the balloon should determine the nature of the caption.

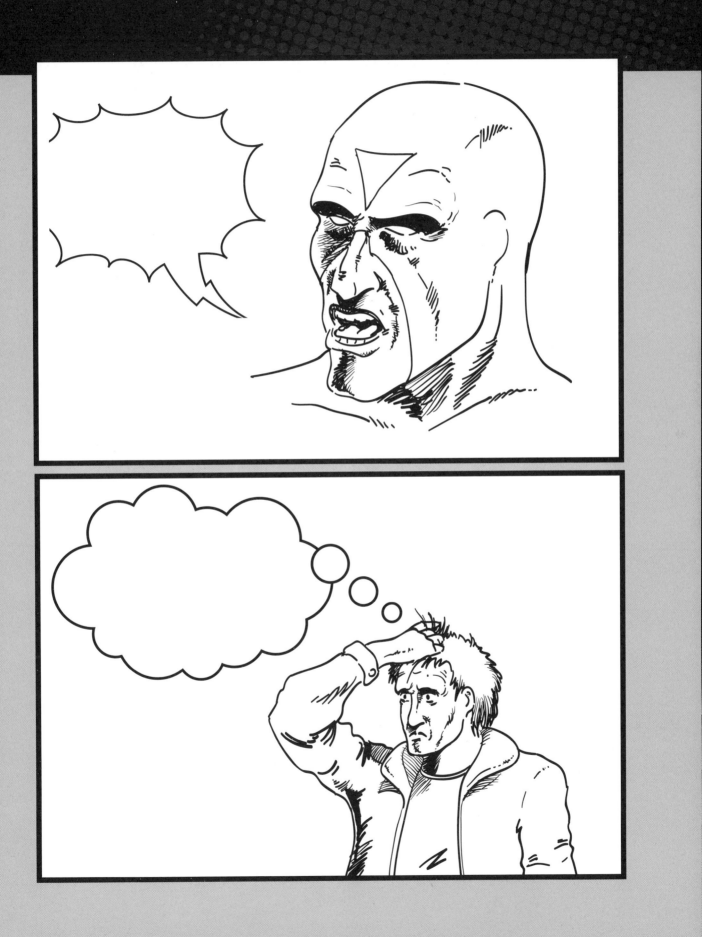

SOUND EFFECTS

There's good news and bad news regarding sound effects. The good news is that sound effects are simple to create. The bad news is that doing them well is tricky—so you need to practice, practice, and practice!

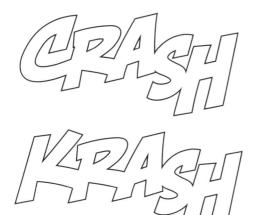

SOUND EFFECTS ARE NOT SIMPLY ONOMATOPOEIA: WORDS WHOSE SPELLING AND PRONUNCIATION ARE DERIVED FROM THE SOUND IT DESCRIBES, LIKE "BOOM." THE SOUND EFFECT SHOULD VISUALLY COMPLEMENT THE ACTION OR SOUND IT IS SIGNIFYING. THIS IS WHY "CRACK" OR "CRASH" ARE OFTEN RENDERED ON THE COMIC PAGE AS "KRAK" OR "KRASH."

NOTICE HOW THE HARD ANGLES OF THE "K" VISUALLY REPRESENT THE HARSH, ABRUPT SOUND BETTER THAN THE GENTLER CURVES OF THE "C." LIKEWISE, A REPEATED "O" VISUALLY COMPLEMENTS THE ROLLING SOUND OF AN EXPLOSION.

KATHOOM

A LETTER LIKE "E" CREATES LATERAL TRAVEL ACROSS THE PAGE FOR THE READER'S EYE WITH ITS THREE HORIZONTAL STROKES. AS SUCH, IT'S EXCELLENT IN A SOUND EFFECT FOR A SKIDDING CAR.

THE ONLY PUNCTUATION YOU'RE LIKELY TO
CONSIDER IS AN EXCLAMATION POINT. JUST
AS WITH DIALOGUE, UPPER- AND LOWERCASE
DENOTE DIFFERENT LEVELS OF LOUDNESS
AND DRAMATIC EFFECT. SO, FOR EXAMPLE, A
SUPERHERO PUNCH IS LIKELY TO BE UPPERCASE.

ARRANGE THE LETTERS SO THAT THEY FIT
WELL ON THE ART AND LOOK PLEASING TO
YOU. REMEMBER THAT LARGER IS "LOUDER"
AND SMALLER IS "QUIETER," SO YOU CAN
CREATE EFFECTS THAT TRAIL OFF OR LOOK
LIKE THEY'RE INCREASING IN VOLUME.

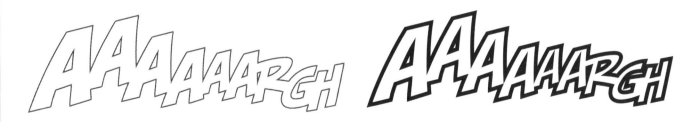

YOU CAN EXPERIMENT WITH OUTLINE THICKNESS, BUT KEEP IN MIND THAT A HEAVY OUTLINE
(STROKE) MIGHT DELIVER SOME UNATTRACTIVE RESULTS.

IT'S YOUR TURN!

Now it's time to put the pieces together; add sound effects and text to the speech bubbles to create your own story!

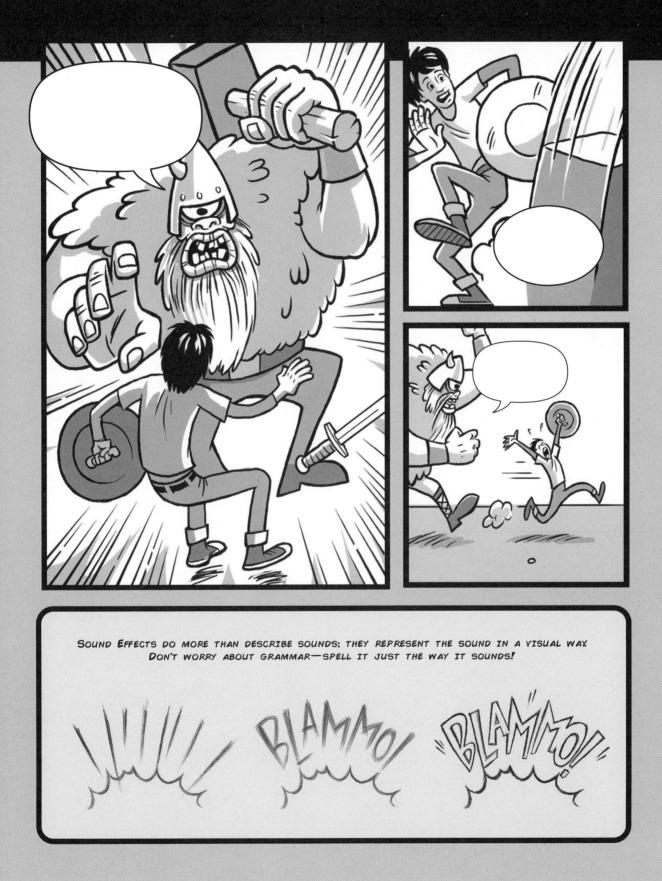

SOUND EFFECTS DO MORE THAN DESCRIBE SOUNDS; THEY REPRESENT THE SOUND IN A VISUAL WAY. DON'T WORRY ABOUT GRAMMAR—SPELL IT JUST THE WAY IT SOUNDS!

Inking Techniques

HATCHING

Hatching uses lines to describe an object's form and to suggest shadows. The lines can vary in thickness to indicate changes in the object's form or intensity of shadows. You can also use simple hatch lines to suggest the inner contours of your figures; however, simple hatching should be done sparingly—it can give your work a tedious appearance. Pens are the best tools for hatching.

CROSSHATCHING

Introduce hatch lines at different angles to build up shadowing or show changes in surfaces. Try to avoid crosshatching at right angles, which can create a dull grid that may detract from your drawing. Crosshatching is a good way to graphically represent gradual changes in tone or shadow.

Master these basic inking techniques, and you'll be off to a great start! Once you have these traditional techniques down, try experimenting with different media and line-making. You can achieve a variety of looks with just a few tools and techniques.

FEATHERING

Generally done with a brush or quill pen, feathering is the iconic comic inking style used by most inkers. There are two distinct strokes: the thick-to-thin stroke and the thin-thick-thin stroke. Both require controlling the pressure you apply when drawing the line. Whether you use a pen or a brush, the greater the pressure you apply as you draw, the thicker the line. Feathering can also be an effective way to render outlines or suggest shadow.

FULL RENDERING

The example at left shows a mixture of rendering techniques: articulated line work for the outlines; feathering and brush-rendered, crosshatched shading; and heavy shadowed areas.

How Does It End?

Use your newfound skills to finish up the comic sequences below!

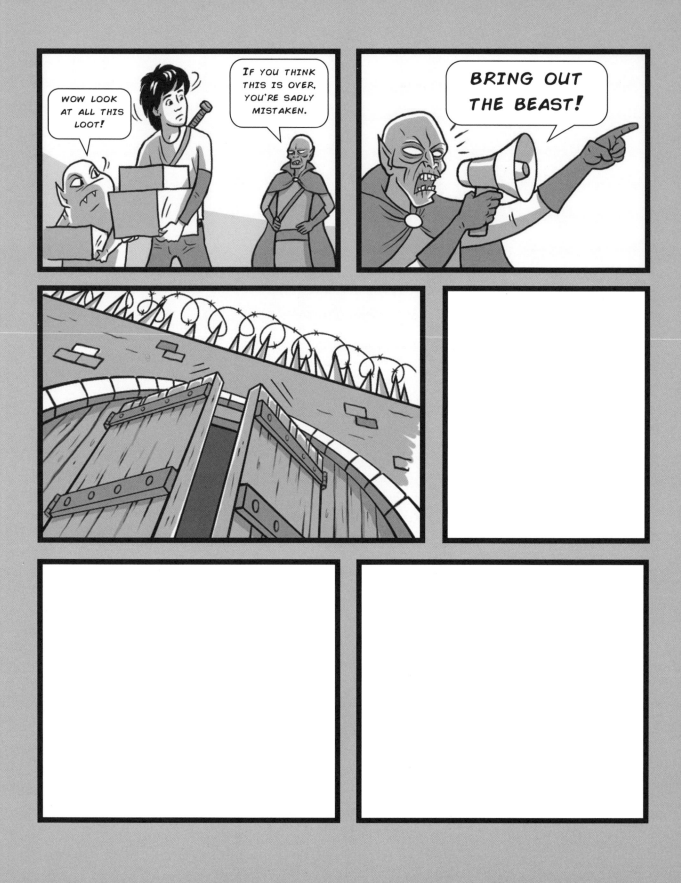

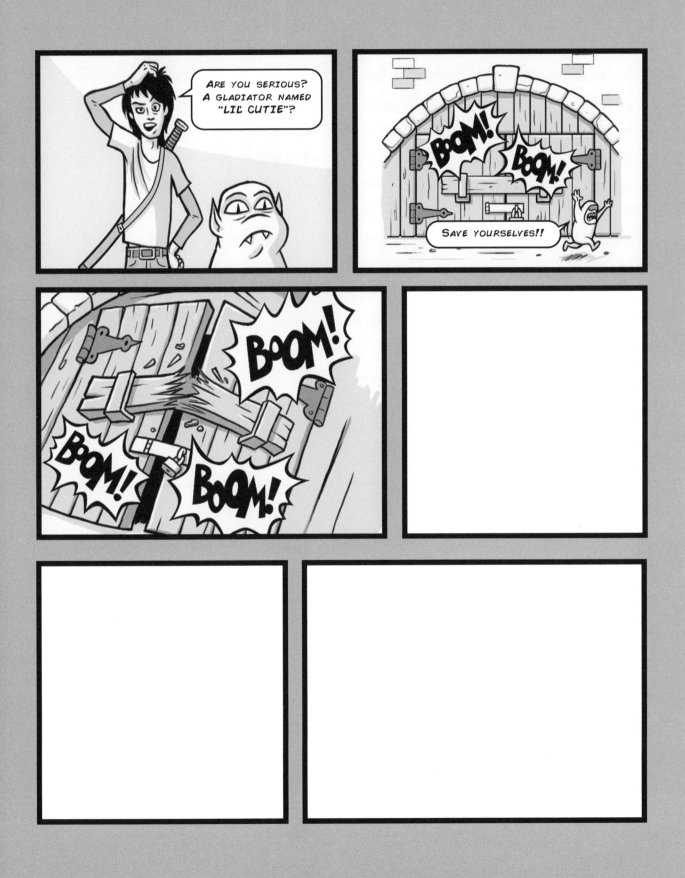

CREATING YOUR OWN COMIC BOOK

It's time to take everything you've learned, and create your own comic book! Grab a pencil and some markers, brainstorm your characters, and devise a story.